Talkback Circuits: New Alphabets at School

Edited by
Anna Bartels, Laida Hadel, Daniel Neugebauer, and Eva Stein

T0047222

Types of Othering

Contents

Talkback Circuits: New Alphabets at School

"Multilingualism: Opportunity or obstacle?" In German schools, this seems to be the key issue when dealing with the language of young people whose first language is not German. There is a general consensus that language has always been subject to change and that youth slang in particular contributes to its development.[1] The benchmark, however, remains the "lingua franca," this grammatically and orthographically correct German that excludes portmanteau words derived from the pupils' language of origin, Anglicisms, and neologisms from digital culture typical of schoolyard slang. Compared with "High German," multilingualism is thus always deemed deficient. This points to an implicit imbalance of power: pupils first have to prove that switching between several languages is not diffuse and confused, but purposeful and goal-oriented; that sprinklings of English, games, and chats do not constitute intellectual impoverishment, but enable inclusive communication. Those who speak and write German correctly do not have to prove this.

Language Politics is Power Politics

Pupils whose first language is not German are a minority; exclusion and discrimination are inevitable. The dominance behaviors at German schools—the suppression of languages—reproduces structures. Aspects of people's identity are repressed and controlled.[2] Even socalled "Kiezdeutsch" (neighborhood German), classified as a youth language and resonating with the speakers' Turkish–Arab immigration stories, is considered incorrect German and must defend itself

1 "Identity creation, provocation, or just for fun: there are many reasons why young people use youth language. Despite sometimes being seen as a threat to language, it is an integral part of growing up and has always existed." See "Was ist Jugendsprache und warum entsteht sie?," *wissenschaft : im dialog* (July 21, 2021), wissenschaft-im-dialog.de/ projekte/wieso/artikel/beitrag/was-ist-jugendsprache-und-warum-entsteht-sie-1/#:~:text=Beim%20Verwenden%20von%20Jugendsprache% 20geht,zu%20anderen%20Gruppen%20im%20Vordergrund, all online sources accessed November 2, 2022.
2 Olenka Bordo Benavides, "Die Bevorzugung der Sprachen," *wir machen das magazin* (October 29, 2019), magazin.wirmachendas.jetzt/ community/die-bevorzugung-der-sprachen/

against prejudice and sanctions. Here, exclusionary mechanisms are at work, motivated not only by racism but above all by classism. Even children and adolescents without a migration history who speak "Kiezdeutsch," especially in large cities, are classified differently than their "High German"-speaking classmates. Their assumed lower level of education is equated with being lower class. And if due to certain physical characteristics these pupils are (literally) "seen" as hailing from outside Central Europe, one expects bad German before they have even spoken.[3] The congruence between language and body politics is obvious. Several volumes of the DNA series, which emerged from the cultural education work of the Haus der Kulturen der Welt, endeavor to read and decipher the latter.

Talkback Circuits: New Alphabets at School looks at language from a power-critical perspective, considering persisting colonial alphabets in the school microcosm, and pointing to possible strategies for deciphering, subverting, and dissolving them.

In her comprehensive essay "Both Poison and Medicine," Leila Haghighat shows how historically and socially evolved orders of power and oppression are "formed" in schools through prescribed languages and curricula and how these shape learners' "ideas about the world." "The linguistic order becomes the dominant order." The narrative of superiority of the dominant group corresponds to the narrative of inferiority on the part of the colonized, all the way into the unconscious, the seat of desire. Theoretician, writer, and psychiatrist Frantz Fanon talks about a collective unconscious, which also includes society's colonized subjects; it sustains the "sum of prejudices, myths, collective attitudes of a given group"[4] and underpins mechanisms of power. It can be overcome through aesthetic education and its resistant practices; however, it is important to recognize and resist the danger of the "double bind"[5] of this very form of education: its

3 Sakina Abushi interviews Professor of Didactics Karim Fereidooni: "Was ist gutes Deutsch? Sprache als Machtinstrument in der Gesellschaft," *ufuq* (May 7, 2019), ufuq.de/aktuelles/was-ist-gutes-deutsch/

4 Frantz Fanon, *Black Skin, White Masks,* trans. Charles Lam Markmann. London: Pluto Press, 1986, p. 188.

5 Leila Haghighat is referring to Gayatri Chakravorty Spivak's *An Aesthetic Education in the Era of Globalization.* Cambridge, MA: Harvard University Press, 2012.

healing potential is countered by the educational canon it is part of, which supports existing power relations.

As poignant practical examples *Talkback Circuits* presents two artistic-aesthetic school experiments, initiated by the Haus der Kulturen der Welt and conducted at two Berlin schools, which explore language in schools, schoolyards, and school textbooks. Here language is analyzed, recognized, complemented, and countered through artistic methods. The colonial legacies in teaching materials—their images and metaphors—are examined and deciphered. New alphabets emerge, giving rise to a new poetics in linguistic and visual space.

In 2021, with the help of artists Franziska Pierwoss and Siska, pupils of the Hermann-Ehlers-Gymnasium created a new common language for the future, exploring the effect of typeface design on the meaning of written language. This was part of *Schools of Tomorrow 3*, a series of artistic school experiments sketching out school utopias in times of digitalization, migration, and the Anthropocene.

In 2022, together with artists Aliza Yanes Viacava and Santiago Calderón García, a Spanish course at the Johanna Eck School explored the Eurocentric colonial narratives of their Spanish textbook and countered them with their own animated films.

Yee Sou Romotow

Yee Sou Romotow is a claim of the new, "free" language invented for the future by twelfth-grade pupils of the Hermann-Ehlers-Gymnasium in Berlin-Steglitz. The pupils conducted language experiments, interviewed fellow pupils with a multilingual background, and used collaborative experiments such as lipreading to develop their own words, inspired by their first and second languages, current colloquialisms, and the French argot verlan.[6]

Leib ocke, Corona behindi Bildu, berechtiggleichung? Nee! The political dimension of this future language is unmistakable. It was created during the coronavirus lockdown by collecting words and artistically processing and reflecting them. It is based on the idea that all

6 Verlan is a playful language common in French youth slang in which
 syllables are reversed. The name verlan is itself an example, reversing the
 syllables of the French *à l'envers* (inverse).

pupils should speak the same language, a planned language that includes multilingualism and highlights exclusionary language policies.

It also involved a certain degree of speculation: how can you communicate at home, in the schoolyard, and on Instagram so that teachers are left out? Why is the children's game *Stille Post* called *Chinese Whispers* in English and *téléphone arabe* in French? How do the design of words and typefaces influence thinking? In collaboration with professional graphic designers, the new terms were given a form that in turn created meaning. In gaudy colors and huge letters, the slogan *Leib ocke* was set against a purple background: fonts from Art Nouveau and Pop Art competed with contemporary typography and chat symbols. At the final presentation of *Schools of Tomorrow 3*, three flags were hoisted on ninety-foot-tall poles on the roof terrace of the Haus der Kulturen der Welt bearing the striking slogans *Leib ocke* and *Yee Sou Romotow*. This "appropriation" of the flagpoles outside the former Congress Hall constituted a reinterpretation of the insignia of institutional power. The pupils' art, as well as their language of the future, subversively played with the effects of typography, sign systems, and institutional identity, resulting in a momentary reversal of the parameters of power.

Under Deconstruction

The pupils of a tenth-grade Spanish course at the Johanna-Eck-Schule, an integrated secondary school in Berlin-Tempelhof, explored colonial thought patterns in their own language acquisition by analyzing their Spanish textbook. Like other European languages, Spanish has a colonial past and present. To what extent is it possible in the German-speaking world to approach Spanish from an anti-colonial perspective? How can colonialism and traditional images of society be dismantled by artistic means? Which alphabets can be used to counter these images?

During six workshop sessions, the pupils closely engaged with their teaching materials, analyzing figurative and written language, identifying negative and positive racism, uncovering stereotypes, and recognizing practices of exoticization and othering. They first watched various video animations from the "(de)colonial glossary" created by Santiago Calderón and Aliza Yanes Viacava to understand and internalize contradictory dualisms such as "modern/primitive," "science/

esoteric," or "civilized/wild." Inspired by Edward Said's idea of an overarching Orientalism as the "background noise" of their perceptions, the pupils developed alternatives to their daily reading, deconstructed and "unlearned" the syllabus, and created new images. This resulted in ten animated short films, which reworked the teaching material in both a humorous and serious fashion. A new hairstyle turns a Mexican mariachi into a punk, conquerors with machine guns occupy an idyllic half-timbered house in Germany, and the supposed idyll of a typical German family is disrupted by images of violence and war. These visualizations all share a political, power-critical attitude: conquest is no longer considered a heroic deed, "ideal" surfaces need to be questioned, forms of othering to be unmasked. The viewers are not confronted with didactic finger-pointing: the films' effect rather lies in the at times playful, humorous deconstruction of the everyday.

The four artists supported the school experiments in the transformative spirit of art education, promoting institutional change and dissolving hierarchical differences between pedagogical staff and learners.[7]

Franziska Pierwoss and Siska's group deconstructed the power of the school apparatus—which classifies pupils based on the sound of their language—with the help of a planned language, invented by and for young people. Its transformative potential lies in the utopia of being able to free oneself from attributions and prejudices and to pursue a political agenda with its own alphabet, its own grammar—beyond existing institutional regulations. The alternative Spanish course literally turns colonial thought patterns on their head, dissecting and reassembling them in a different manner. Artists Santiago Calderón and Aliza Yanes Viacava encourage young people's collective creativity by deconstructing traditional images of history. They also point to a blind spot in the German school system, whose curriculum does not include an in-depth examination of European colonialism. Without the commitment of individual educators, the link between stereotypical representations and (post-)colonial power relations would be ignored

7 Carmen Mörsch, "Am Kreuzungspunkt von vier Diskursen: Die Documenta 12 Vermittlung zwischen Affirmation, Reproduktion, Dekonstruktion und Transformation," *What's Next*, 249 (2009), whtsnxt.net/249

in the classroom. Through the work of the Spanish course and the re-sulting animations, the utopia of a just world without exclusion and oppression of colonized groups was realized, at least artistically.

Whether the aesthetic education practiced in the two projects is affected by the "double bind" mentioned at the beginning of this piece cannot be determined at this point. In any case, the blueprint for a utopia that eludes the reality constraints of colonial narratives was successful. "Part of our learning process must include pushing the imagination to the limits of what is possible and of what is impossible, and only then to learn to what extent it is compatible with reality [...]—each person should be able to figure out what her or his personal uto-pia is at the beginning of the educational process, and then learn to what extent it is compatible with desires, possibilities, and other uto-pias—and with reality."[8] The present volume shows how Luis Cam-nitzer's utopia was realized in the practice of two schools.

Eva Stein

Translated from the German by Kevin Kennedy

8 Quoted from the interview: "Vom Scheitern und Nichtwissen: Über Kunst an der Schule und im Museum. Luis Camnitzer im Gespräch mit Francisca Zólyom," in Silvia Fehrmann (ed.), *Schools of Tomorrow*. Berlin: Matthes & Seitz, 2019, p. 112.

ROWOT 2

Corona behindi Bildu

schu so förd

Danke de Zeitschwendung

De wichtig nix Schule

De Schule kein NWDK!

Schif nnak ncik mann
hcoh tteklern

Leib ocke

Wie redn, se hör zu

berechtiggleichung? Nee!

Rowot 2 (Word 2):
The newly invented sentences

Corona behindert die Bildung
[Corona impedes education]

Schule soll fördern
[School should offer support]

Danke für die Zeitverschwendung
[Thanks for the waste of time]

Die Schule ist nicht wichtig
[School is not important]

Die Schule ist keine Notwendigkeit!
[School is not a necessity!]

Der Fisch kann keinen Baum hochklettern
[The fish can't climb a tree]

Bleib locker
[Take it easy]

Wir reden, sie hören zu
[We talk, they listen]

Gleichberechtigung? Nein!
[Equality? No!]

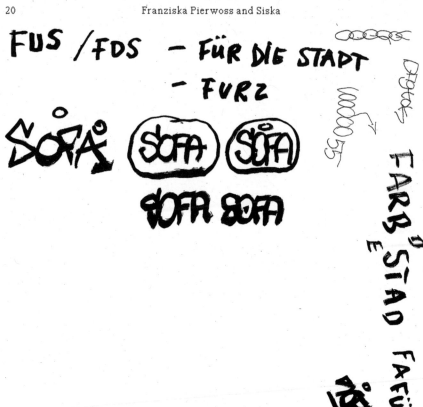

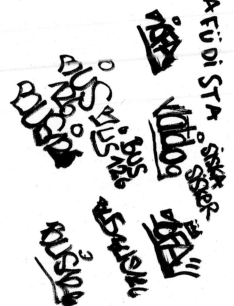

Notes 1 Research:
A walk with the Graffiti Museum

NDA - GEHEÏM

HANZ -

HERTA

AMC - KRANKHEIT

79 41

C 64 italische Rev

§79

94 WAHLKREIS

GOVERMENT

ISSUE

T68 - Tag 8 Nacht

ZERK - türk. Spritze

fließende uhr

Notes 2 Research:
A walk with the Graffiti Museum

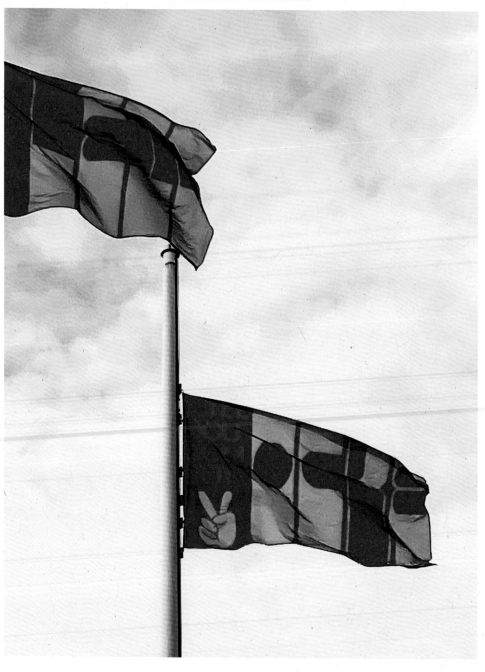

LEIB OCKE – *Yee Sou Romotow*:
The flags hoisted at HKW
photo: Siska

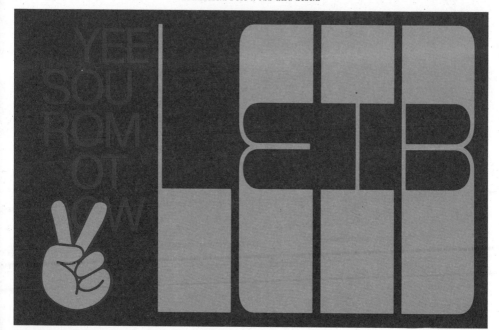

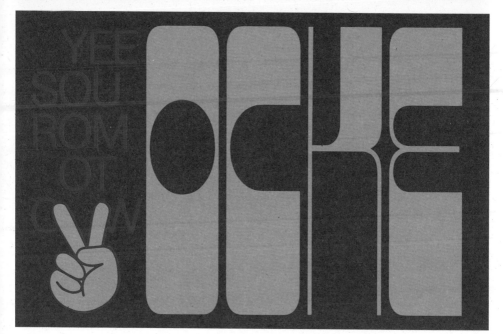

LEIB OCKE – *Yee Sou Romotow*:
The flag design chosen by the school students
design: arc and the students

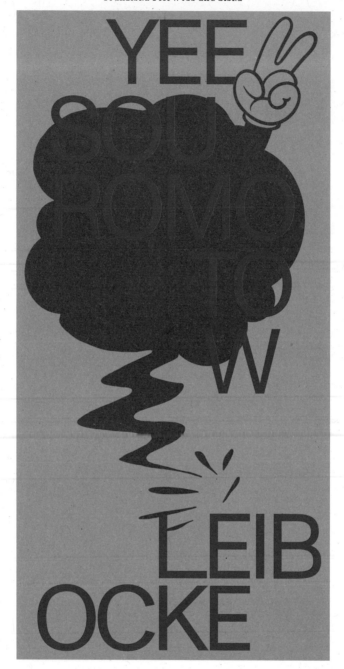

LEIB OCKE – *Yee Sou Romotow*:
The vertical flag design chosen by the students
design: arc and the students

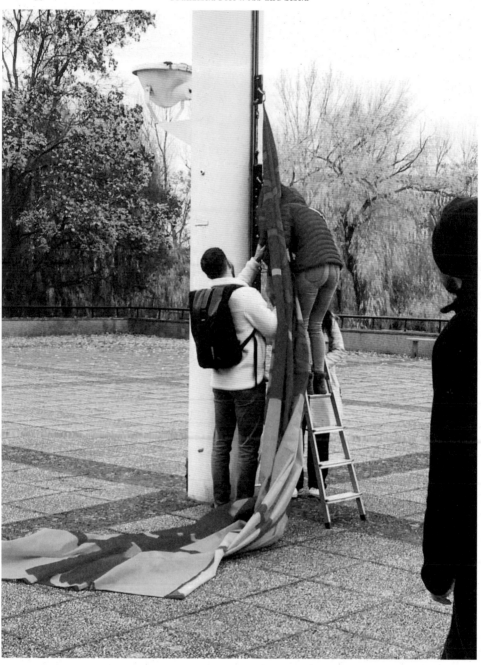

The school students raise the flag at HKW
photo: Franziska Pierwoss and Siska

The video of the working process with the students can be found here:
https://vimeo.com/siskastudio/yeesouromotow
(QR-Code on page 65)

With the students of Hermann-Ehlers-Gymnasium, Berlin – LK KI Q3,
accompanied by Simone Klar:

Amani Moussa
Berrin Oezgen
Chantal Choudhary
Efecan Özkeçeci
Helin Canbay
Kevser Sirganci
Layan Sleiman
Lea Maxima Gorgs
Irina Kunpan
Vildane Rexha
Xuan Tien Nguyen
Yoonji Lee

Yee Sou Romotow (see u tomorow) – leib ocke – rowot2 – #dearfuture
Haus der Kulturen der Welt – *Schools of Tomorrow* – Berlin 2021
A project by Franziska Pierwoss and Siska
In cooperation with the Graffiti Museum and arc-gestaltung

laudival

agree

¡VAMOS! ¡ADELANTE!
¡A INTERVENIR EL COLEGIO!
Spanish Lessons, Social Images, and Stereotypes

Learning a foreign language is not just about mastering grammar, vocabulary, and pronunciation. The learning process also involves an examination of the social images associated with the target language. Unlike first and/or bilingual language acquisition, language teaching is institutionally regulated,[1] organized by teachers on the basis of curricula and the learners' different levels of competence. Thus, it is often the teaching materials and the foreign language teaching themselves that produce the social images associated with the countries where the target language is spoken. In the case of teaching Spanish, these ideas are not only linked to Spain, but to the Latin American countries where Spanish is an official language.[2]

The Spanish language has been used in these nations shaped by a colonial system since the sixteenth century to denigrate colonized societies and thereby articulate *white* dominance.[3] In addition to words, visual images have further reinforced colonial thought patterns, which forcibly characterized and classified different societies as either "savage" or "civilized" through visual and verbal discourses.

The Eurocentric idea of the region has been fueled by series of illustrations forming part of a system of representation to bring "Latin America" closer to the historical construct of the "West" while also designating it as an "underdeveloped" or a "developing" region.[4] The

1 Britta Günther and Herbert Günther, *Erstsprache, Zweitsprache, Fremdsprache*. Weinheim: Beltz, 2007, pp. 57f.
2 In the classroom, the Spanish-speaking world is usually limited to Spain and Latin America. Yet Spanish was and is a colonial language spoken in other regions of the world, too, for example in Equatorial Guinea.
3 Susan Arndt, "Sprache, Kolonialismus und rassistische Wissensformationen," in Susan Arndt and Nadja Ofuatey-Alazard (eds), *Wie Rassismus aus Wörtern spricht, (K)Erben des Kolonialismus im Wissensarchiv deutsche Sprache. Ein kritisches Nachschlagewerk*. Münster: Unrast, 2011, pp. 121–25.
4 See Stuart Hall, "The West and the Rest: Discourse and Power," in Stuart Hall and Bram Gieben (eds), *Formations of Modernity*. Cambridge: Polity Press, 1992, p. 277.

corresponding pictorial and textual representations simplify, hierarchize, and obscure the complexity of those societies.

The content of the teaching materials as well as the attitudes of teachers towards them may lead to the consolidation of stereotypes among students. But they can also be used to deconstruct existing images and prejudices.[5] What does a (self-)critical education against the legacy of coloniality look like? How can we explore the topic of colonialism and the social images and attributions in Spanish textbooks in German-speaking countries? And if this requires a new alphabet in schools, what exactly should that new alphabet look like?

The following text describes the activities, observations, reflections, and results of a workshop with tenth-grade pupils at the Johanna-Eck School on the topic "Social Images in Spanish Classes". The aim of the workshop was to critically examine the teaching materials, to understand the textbook's image politics concerning colonialism and colonial continuities, and, based on these reflections, to develop a series of image interventions using stop-motion animation techniques.

First, we would like to shed some light on the structure and conditions in which the workshop took place. We will, therefore, examine various aspects of the Berlin *Framework Curriculum* for secondary level 1 and explain the project's background and theoretical starting points.

Spanish as a *Foreign* Language

In Berlin, the current concept of multilingualism for schools includes "bilingual subject teaching", "foreign language teaching", and "language-of-origin teaching".[6] Within this structure, Spanish courses at

5 Carmen Mörsch, "Critical Diversity Literacy an der Schnittstelle Bildung/ Kunst: Einblicke in die immerwährende Werkstatt eines diskriminierungskritischen Curriculums" (2018), *Kulturelle Bildung Online* https://kubi-online.de/artikel/critical-diversity-literacy-schnittstelle-bildung-kunst einblicke-immerwaehrende-werkstatt, accessed October 15, 2022.

6 Mark Hamprecht, "Der Stand des Mehrsprachigkeitskonzeptes für Berliner Schulen," in Yekmal Akademie (ed.), *Best-Practice-Beispiele und Praxismodelle für zweisprachige Schulen: Präsentationen aus der Fachtagung zum Tag der Muttersprache 2021.* Berlin: Yekmal Akademie, 2021, pp. 21–27.

Johanna-Eck School (an integrated secondary school) are classified as elective "foreign language classes" in the field of "Modern Languages." This means that they are subject to the guidelines of Section C of the joint *Framework Curriculum* for Berlin and Brandenburg (grades 1 to 10). This section describes the goals of modern foreign language teaching, the subject-related competencies, and the topics and content students should learn.

One point in the *Framework Curriculum* is defined as "intercultural communicative competence", which also includes the critical questioning of stereotypes.[7] In this context, "becoming acquainted with the social, political, and economic conditions in the countries where the target language is spoken" is defined as the basis for unprejudiced reflection.[8] According to the Berlin Senate Department for Education, Youth and Family Affairs and the Brandenburg Ministry for Education, Youth and Sport, the aim is to promote a respectful attitude toward "other cultures".[9] However, a clear stance against the historically nurtured power structures that sustain hierarchical and stereotypical views of "foreign" societies through language is missing. Topics such as "colonialism" only feature as options for further exploration. In other words, the authors of the *Framework Curriculum* do not establish an explicit link between stereotypical representations and colonialism.

Although the topics suggested in the *Framework Curriculum* are mandatory, the content of classes is determined by the individual teachers. Thus, a deeper exploration of topics such as colonialism and stereotypes in Spanish lessons depends to a large extent on the school or the teacher. An inclusion of these topics does not necessarily mean

7 Ministerium für Bildung, Jugend und Sport des Landes Brandenburg (ed.), *Rahmenlehrplan. Teil C. Moderne Fremdsprachen. Jahrgangsstufen 1-10*. Berlin: Senatsverwaltung für Bildung, Jugend und Familie des Landes Berlin, 2015.

8 Ibid., p. 35.

9 Senatsverwaltung für Bildung, Jugend und Familie des Landes Berlin (ed.), *Rahmenlehrplan 1-10 kompakt. Themen und Inhalte des Berliner Unterrichts im Überblick*. Berlin, 2017, p. 78. The compact version of the *Framework Curriculum 1-10: An Overview of the Subjects and Content Taught in Berlin* is available as a PDF in English via https://berlin.de/sen/bildung/unterricht/faecher-rahmenlehrplaene/rahmenlehrplaene/

that they will be explored in a power-critical manner. Failure to establish historical connections in any critical examination of social stereotypes may end up focusing merely on a (colorful) diversity of individuals rather than on the "norms and structures that produce relations of force".[10] It is essential, therefore, to include as fixed components of the "modern languages" curriculum topics that promote a critical examination of power and discrimination. Teacher training programs should also teach these topics.

From the Beginning: The Dualistic Representation of Reality—Theoretical Starting Positions

Both in Europe and in the territories formerly colonized by Europe, the images associated with particular societies and the hierarchy built around languages are anchored in a Eurocentric logic shaped by colonialism. Which languages do people learn today when motivated by the ambition to emigrate, work, go on vacation, or study? Which languages represent prestige or talent? Which are ignored, discredited, censored, or suppressed? In the context of European colonialism, language was (and is) an important means of enforcing *white*, European, male, Christian dominance.[11]

Developed by Peruvian sociologist Aníbal Quijano, the concept of the "coloniality of power" is very useful for talking about colonialism and its continuities in the present. Quijano notes how the colonial system persists today through "coloniality", a form of power that produces asymmetric political and economic relations across the globe.[12] Eurocentric logic positively represents and universalizes

10 See the remarks by feminist theorist Stefanie Claudine Boulila in her contribution "Ist Diversity antirassistisch? Ein Kommentar zum Verhältnis von Diversity Politics und den Politics of Diversity aus der Perspektive der Race Critical Theory," in Serena O. Dankwa, Sarah-Mee Filep, Ulla Klingovsky, and Georges Pfruender (eds), *Bildung. Macht. Diversität: Critical Diversity Literacy im Hochschulraum*. Bielefeld: transcript, 2021, p. 85.

11 Arndt, "Sprache, Kolonialismus und rassistische Wissensformationen."

12 Aníbal Quijano and Michael Ennis, "Coloniality of Power, Eurocentrism, and Latin America," *Nepantla: Views from South*, vol. 1, no. 3 (2000), pp. 533-80, here pp. 540-42.

Western knowledge, while ignoring, instrumentalizing, and/or rendering invisible the knowledge of the "rest of the world". Quijano locates the origin of this hierarchical system in the conquest of the Americas. In one of his key phrases, he claims: "Modernity, capital and Latin American were born on the same day."[13] In other words, by conquering the territory then known as Abya Yala,[14] the discourse of modernity was created by Europe as an overcoming of the Middle Ages, establishing an economic model based on exploitation on a planetary scale, and renaming Abya Yala America. Founded on opposing dualisms, this discourse posits a supposedly radical difference between the colonizers and the inhabitants[15] of these then "unknown territories".[16] Before the "discovery" of America, there was no concept of "Europe" or "Europeans" as we know it now. At the same time, intersubjective relations between Europe and the rest of the world were conceived of in diametrically opposed categories: civilized/wild, modern/primitive, scientific/magical-mythical, rational/irrational, and so on.[17] Quijano explains that the basis for this difference was established by the previously non-existent category of

13 Aníbal Quijano, "La modernidad, el capital y América Latina nacen el mismo día," in *ILLA, Revista del Centro de Educación y Cultura*, no. 10 (1991), pp. 42–57.

14 In the Guna language of Panamá, Abya Yala is the name for the American continent and means "land in full maturity." It is used today by Indigenous societies and their supporters as a counter-concept to the colonial term "America." See Carlos Walter Porto-Gonçalves, "Abya Yala," in *Enciclopedia Latinoamericana*, 2006, http://latinoamericana.wiki.br/es/entradas/a/abya-yala, accessed October 15, 2022.

15 Quijano and Ennis, "Coloniality of Power, Eurocentrism, and Latin America," p. 533.

16 In "The West and the Rest: Discourse and Power," Stuart Hall discusses this strategy of constructing what is called the West, starting with Christopher Columbus' "discovery," and delineating how, over the centuries, this construct spread throughout the world. His main focus is on the way the West represented the "others" by distinguishing between "us" / "Europe" and "the others" / "the rest of the world." See Hall, "The West and the Rest."

17 Quijano and Ennis, "Coloniality of Power, Eurocentrism, and Latin America," p. 552.

raza (race).[18] The concept of *raza* grounds and underpins the superiority of *white* European man, whose task it is to civilize the "new world" and teach it the "true religion".[19]

Recognizing and Naming Opposing Dualisms: 'The (De)colonial Glossary" as a Mediation Tool[20]

So successful and well-established is the discursive, dualistic representation of reality, that first we must perform an "interpretive exercise" to even recognize and challenge it. On the one hand, historical knowledge is important to contextualize the origin of such representations; on the other, we must establish a link with the present to see how and in what forms this discourse continues to operate.

18 Ibid., pp. 534f.
19 Encouraged and strengthened by the reconquest of the Iberian Peninsula after 800 years of Arab domination, the Christian church was convinced that it was its mission to bring its teachings to the rest of the world. It is not surprising that in the first chronicles of the Spanish invasion, adjectives associated with the Arab world were used to describe the way of life of the inhabitants of Abya Yala. For example, the chroniclers referred to the Wak'a (Quechua; usually spelled huaca in colonial documents), the sacred temples of the Andean world, as mosques. The inhabitants of Abya Yala were not only defined and labeled as inferior but likened to Arabs, establishing an arbitrary connection between different societies. See Raúl Porras Barrenechea, *Obras completas de Raúl Porras Barrenechea I. El legado quechua*. Lima: Fondo Editorial Universidad Nacional Mayor de San Marcos, 1999, pp. 168f.
20 "The (De)colonial Glossary" was created as part of the experimental study project "DecolonizeM21," a cooperation between the National Museums in Berlin—Prussian Cultural Heritage Foundation and the Institute for Art in Context at the Berlin University of the Arts—and supported by the Federal Commissioner for Culture and the Media. The project, dedicated to contextualizing the content of Module 21 of the Humboldt Forum, shows the cultural heritage of the Moche, Nazca, and Inca cultures in Peru today. Based on Aníbal Quijano's theory of the coloniality of power, the project was developed within a *white*, European, essentially colonialist institution founded on the binary "we = Germany/Europe" and "the others/outside Europe."

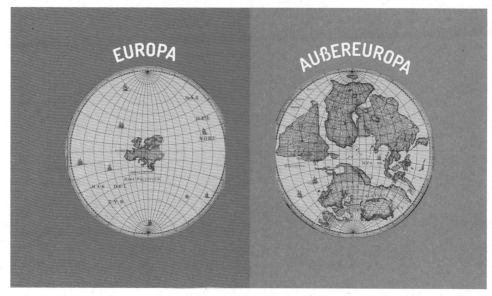

Video still from the project "Intervention M21" (www.decolonizem21. info): "Das (De)koloniale Glossar. Wie Wörter die Realität gestalten" / "El Glosario (De)Colonial. Cómo las palabras construyen la realidad," Part 1: *Europa/Außereuropa* ("The (De-)Colonial Glossary," Part 1, *Europe–Outside Europe*)| © Aliza Yanes Viacava & Santiago Calderón A QR-Code to the films is to be found on page 65 of this volume.

Since contrasting pairs can be a very abstract exercise, our project "The (De)Colonial Glossary" wanted to make this dualistic construction of reality accessible to a broader audience by using simple language. Consisting of four video-collage animations of colonial terms and representations, the Glossary is organized around contradictory dualisms: European/non-European, civilized/wild, modern/primitive, scientific/esoteric. The aim is to make the colonial idea of reality visible through words and images and to thereby criticize Eurocentrism. Counter concepts from Abya Yala's Indigenous thought are presented as alternatives. Combining historical images with contemporary illustrations, the videos highlight the continuity of colonialism in the present.

The Glossary's videos served as a starting point for cultural and educational projects in schools,[21] much like our project in the Spanish course at the Johanna-Eck School, for example. The explanatory films were intended to provide a basic background against which to explore social images in Spanish teaching materials from a power-critical perspective, including a critique of Eurocentric thought patterns and taking a conscious approach to Spanish language learning.

¡Vamos! ¡A intervenir el libro del colegio!
Spanish Language Teaching, Colonialism, and Social Images

The following questions were posed at the beginning of the workshop: how often do the pupils have history classes? How much time is devoted to the topic of colonialism in their history classes? Do pupils know about German colonialism and understand that colonialism is more than just the occupation of territory by force?

According to the young people, they had not addressed this topic before. They were not familiar with the Spanish invasion of Abya Yala that began in 1492 in what is now the Americas. Yet they could recognize and label stereotypes—in the media and video games, for example. That is why we decided to focus on this aspect. The workshop was conceived as a critical intervention in the pupils' learning materials, which reproduce a series of stereotypical social images from the Spanish-speaking world. Over the course of several sessions, we tried to convey the extent to which this is a consequence of colonialism. Together with Spanish teacher Claudia Donau-Green, we discussed and agreed on some of the content and our role in this project. It should be mentioned that we perceived ourselves—as teachers—as bearers

21 One of these projects was "Sicht der Dinge" (Points of View), in which we explored the topic of colonialism and art over a five-month period with photographer Veronika Albrandt and a Berlin-based advanced art course. Pupils produced stop-motion video animations examining colonial continuities in their everyday reality. These experiences sparked our interest in exploring the transition from discussions about the critique of colonialism to practicing a power-critical dynamic in the classroom. The project was carried out in cooperation with the Fritz-Karsen-Schule, the Andenbuch bookshop, and the Schillerwerkstatt e. V., funded by the Berlin Project Fund for Cultural Education.

of the knowledge that was about to be imparted, which conflicted with our goals. Although certainly, as our role is that of mediators, we by no means consider ourselves to be the undisputed providers of this content. It was our aim to foster a critical, analytical attitude in the young people: towards the Spanish textbook, the Spanish lessons, and the people transmitting the knowledge—including ourselves.

During their Spanish lessons at Johanna-Eck School, pupils of all grades currently work with the textbook ¡*Vamos Adelante!* published by Klett, Stuttgart, in 2014.[22] Reading through the volume, our first step was to pay particular attention to the images representing Germany and Spain, as well as the Latin American countries. The result speaks for itself: the images of Latin American people include pictures of the poor, victims of drug cartels, the homeless and unnamed children. These images and violent representations feature in exercises that ask pupils to, for example, correct the grammar and spelling mistakes of peasant children from the Andes.

On the Sessions

In the first session, besides getting to know the pupils, we presented the first video from "The (De)Colonial Glossary," *Europe/Outside Europe*. This recounts how, ever since the conquest of Abya Yala, Western culture has presented itself as the paradigm, dividing the entire planet into two halves: Europe forms one part, the rest of the world the other. As the lesson progressed, we divided the board into two halves, one for "Europe", to be covered with red slips of paper, and one for "Outside Europe", to be covered with blue slips of paper. Pupils were asked to write words, terms, and characteristics they associated with each concept on red and blue paper and to then pin them on to the corresponding side of the board. After the exercise, one half of the board was red, the other blue. In the next step, we asked the pupils which terms or words they had placed on one side might also belong on the other.

The aim of the exercise was to encourage reflection on our ideas and perceptions of the concepts "Europe" and "non-Europe" and to show that the binary division of the world is arbitrary.

22 ¡Vamos! ¡Adelante! 3, *Grammatisches Beiheft*. Stuttgart: Ernst Klett, 2016.

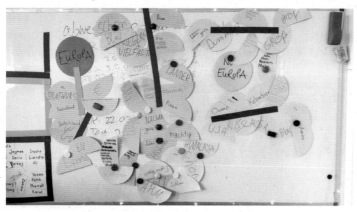

Exercise: "Europe/Outside Europe," Session 1

The second session took place following a trip the pupils had made to Barcelona as part of their Spanish course. We watched the second video of the "The (De)Colonial Glossary" entitled *Civilized/Savage*, which explains how these binaries were used by European conquerors to distinguish themselves from colonized societies. Afterwards, the students were asked to write down the words they associated with the term "Spanish". In this phase, the focus was on the power of words: they can be oppressive, but also empowering; they can even "feel good".

Pupils' notes, Session 2

In the next session, we watched the third video from the Glossary featuring the opposition "modern/primitive" and the term "exoticization". The latter was important for broaching the topic of stereotypes and social images.

> *EXOTICIZATION*
>
> *Creates stereotypes. The unknown is assumed to be different, a difference expressed in literature, and further constructed and consolidated with the help of pseudo-scientific "race theories". For their part, museums in the nineteenth century distorted perceptions of other societies through exoticization. Later, this idea was massively reinforced by the press, advertising and mainstream culture.*[23]

Vocabulary for teaching Spanish, Session 3

The conceptual definition of exoticization formed the basis for our conversation in German and Spanish about the video. The pupils identified terms that were closely related to the concept of exoticization: stereotype, prejudice, racism, unusual, but also "positive" prejudice

23 Transcript from Part 3 of "The (De)colonial Glossary."

associated with the idea. The lexical field established during the lesson served as a starting point for further exploration of the images in their textbook.

We took a closer look at the following images from the Spanish book:

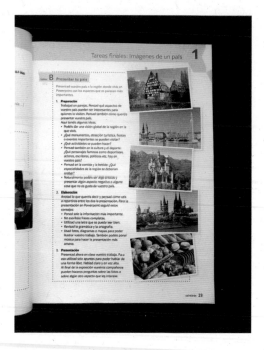

¡Vamos! ¡Adelante!, Curso intensive 1. Grammatical Supplement 3. Stuttgart: Ernst Klett Schulbuch, 2016, p. 23

What comes to mind when we look at these pictures? What country might they depict? What do the images convey? Do these pictures represent a familiar everyday reality? One student mentioned an important point: there are no people in these photos, only places and food.

In order to move from a general to a more personalized image of Germany, each pupil was asked to select five images from the Internet that represented their own everyday reality. Contrary to what we expected, the images reflected their relationship with the Internet and social networks, rather than their physical environment (school, neighborhood, etc.).

Screenshots of the pupils' online searches, Session 3

In the next session, we began by introducing the class to the concept of "othering" with a video from the Instagram channel "Erklär mir mal",[24] which presents political and educational content from (post-)migrant and queer perspectives. Our idea was to relate the term to the words that had surfaced during the discussion of the previous session—namely exoticization, cliché, stereotype, prejudice, racism, "positive" prejudice, colonialism, exotic and unusual. Working in groups, pupils were asked to choose an image from their Spanish textbook that they thought reflected some kind of stereotyping and then to visually intervene and change the meaning of the image by, for example, using collage techniques.

In preparation for the next session, in which we would create our own videos, the suggestion came up to use one of the words we had worked with in class as a starting point. We then looked at how to create a storyboard. Again, the pupils were asked to choose an image from their Spanish textbook on which to intervene. This time, however, they had to create a stop-motion video and thereby change the meaning of the original image: they used artistic strategies such as recombination, overpainting, overdrawing, exaggeration, alienation, and recontextualization of the figures to deconstruct the images Eurocentric outlook and give them a new meaning.

24 *Erklär mir mal* (Explain to me) "Othering," January 1, 2021, Instagram https://www.instagram.com/p/CJY9S47H9uc, accessed October 15, 2022.

The sixth and final session was devoted exclusively to video production.

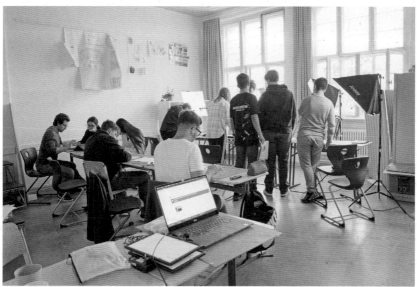

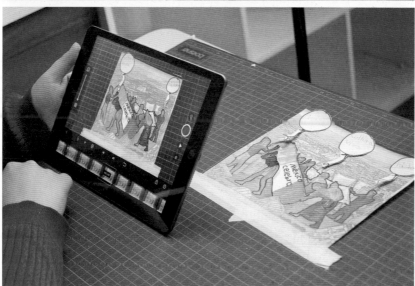

Photos of the stop-motion workshop set up in the classroom. Photos by Elkin Calderón.

On the Stop-Motion Videos

The pupils could freely choose and interpret whatever they wanted to associate with the stereotypes and continuities of colonialism. This resulted in an eclectic array of animations touching on stereotypes in general and sometimes referencing the pupils' own reality.

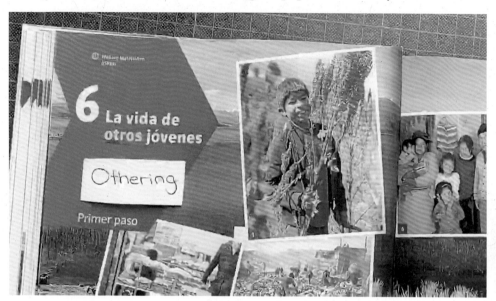

Still from the video intervention based on page 104 of the book
¡Vamos! ¡Adelante! 3

One pupil decided to work with the term "othering". She started off with a picture from her textbook that directly alluded to the lives of other teenagers, and then explained what "othering" means and the different forms it takes.

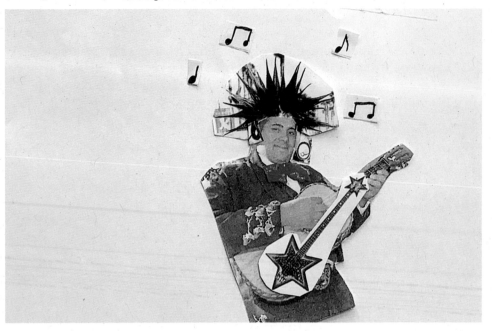

Still from the video intervention based on page 10 of the book
¡Vamos! ¡Adelante! 3

The textbook portrays Mexico as a colorful country, a mix of ancient
and modern, with high levels of crime and poverty. Images of maria-
chi are typically used to represent Mexican music. Here, a student de-
cided to turn a mariachi performer into a punk.

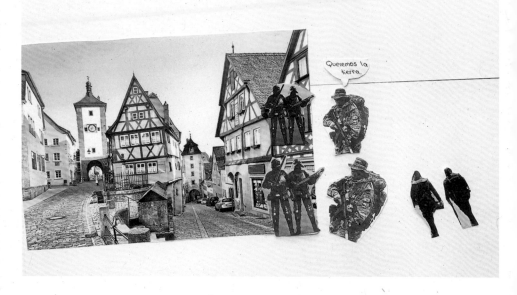

Still from the video about the conquest of a German village

Not all the videos were based on images from the students' textbook. This one, for example, contextualized the dynamics of conquering land in a German village. The struggle for land is a major theme of colonization—this is still a highly topical subject in Latin America.

Still from the video intervention based on page 12 of the book
¡Vamos! ¡Adelante! 3

Some students were interested in Mexican traditions. This student in-
tervened in an image from the past to present the vibrant culture of
contemporary Mexico firmly rooted in its Indigenous cultures.

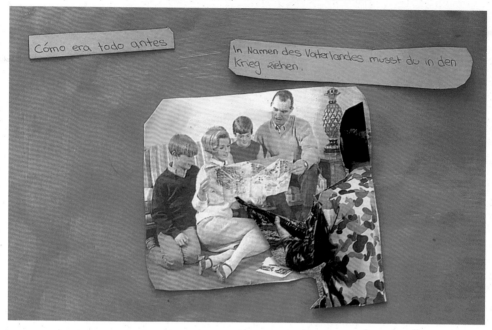

Still from the video intervention based on page 38 of the book
¡Vamos! ¡Adelante! 3

Another student intervened in an image from the textbook depicting
a white middle-class family. While the textbook portrays life "in the
old days" as technology-free, thus giving people more time for each
other, the video challenges this idea with images of family breakdown
resulting from military service and war.

Concluding Remarks

Our goals for the workshop were ambitious: to critically examine images in school materials that depict society and social life and the extent to which they reveal colonial continuities. Due to the complexity of the topic, the discussion of stereotypical social images took place in German. This was a challenge for us as art educators and native Spanish speakers, so we translated phrases from Spanish into German to convey in simple terms what we wanted to say without sounding too academic or abstract. In addition, there were our own contradictions and complexities: hailing from Colombia and Peru, from different contexts, and occupying a different social position there than here in Germany where we are migrants from "outside Europe"; identifying and fighting Eurocentrism while living in Germany and speaking its language; working with young people from different social and cultural backgrounds who were born and live in Berlin, but whose realities we do not or did not share.

Addressing a topic like colonialism in a school context requires constant self-reflection. Each and every one of us occupies a place in the global system of "coloniality of power". Asking yourself what you should and can do from this place triggers an open-ended process. The answers are not set in stone; possible solutions continue to evolve, change, and improve. It is collective work. Our artistic and mediating practice is part of an emerging learning and research process which must adapt to the needs of the target group we are working with.

When working with young people on such a topic it is important to create an atmosphere of trust and safety in which it is possible to make mistakes and ask questions without fear of negative judgment. The decisive factor here is time. We need time to build this relationship of trust. Time to understand the needs of every student. Time to explore in-depth a subject as complex as colonialism and its consequences. At school, there is a tendency to see grades as the main motivation for pupils.

Although grades can be important in the school system, this issue goes well beyond formal evaluation. It provides knowledge and life tools, training pupils who will later work in a wide variety of professions, and who can play a different role in society if they are aware of the colonial and racist structures in which we live, recognizing, dismantling, and combatting them.

What we set out to do in the workshop cannot and should not be done alone. In light of the goals of the workshop, various actors must be actively involved. Yet to what extent does the school institution provide the necessary structures to ensure that the topic is addressed? This brings us back to the *Framework Curriculum* for foreign language teaching in Berlin and Brandenburg mentioned at the beginning. Although it calls for these lessons to be critical of discrimination, it is ultimately up to the teachers to decide how they want to use the teaching materials and what topics to introduce. Considering the amount of work teachers have to do anyway, is it likely they will find the time and the motivation to include material that is critical of colonialism or to engage critically with the existing material? Do teachers have the necessary tools to choose to use discrimination-critical teaching materials or, if necessary, create them themselves? Is it reasonable to expect that workshops by external experts, which only last a few hours, will compensate for the lack of colonial-critical material in many subject areas taught in schools? Undoubtedly, in order to break with Eurocentric representations that perpetuate power relations from the colonial era, a new alphabet in schools is necessary. The vocabulary created during the workshop might serve as an example here. However, this new alphabet needs to be embedded within institutional structures that facilitate its comprehension and benefit all those involved: students, teachers and mediating artists.

Let's intervene!

Translated from the German by Kevin Kennedy

The project was carried out with the 10th grade students of the Johanna-Eck School, accompanied by Claudia Donau-Green.
Dalia Berjawi, Moritz Brors, Lilas Koushak, Pascal Nehls, Vivien Elke Schröter, Kadir Arslan, Amani Kayed, Yusuf Eren Kilic, Mahmoud Koushak, Melisa Yolcu, Mika Siemer-Thole

Both Poison and Medicine:
Language and Aesthetic Education
in Schools in the Mirror of Colonial
Continuities

If children and young people are still faced with (structural) racist discrimination at school in the umpteenth generation, it must be seen as a legacy of colonialism. This is expressed in the term postcolonialism. It is transmitted, for example, through the language prevalent in school. The colonial racist legacy is literally inscribed in language use. As providers of learning content, schools still play a vital role in perpetuating the symbolic order of colonialism today because this content permeates the (collective) unconscious. My article "Unabgeschlossene Geschichten" (Unfinished Stories), on which the present text is based, illustrates this by means of the Columbus-as-discoverer myth.[1]

In order to legitimize colonialism and its brutal exploitation of people and nature, narratives of superiority were needed to convince both the colonizers and the colonized. This involves an interplay of coercion and consensus, domination and leadership, as described in Marxist philosopher Antonio Gramsci's theory of hegemony. A consensus must be "formed" to ensure the moral-intellectual leadership of the white majority. For Gramsci, "every relation of 'hegemony' [...] is necessarily a pedagogical relation,"[2] which makes the school—the state's key education institution—the central site of social reproduction.[3] Here, this interplay is particularly evident, since school not only teaches young people socially desirable behavior—consensus—but also disciplines them.

1 Leila Haghighat and Karen Michelsen, "Unabgeschlossene Geschichten? Das Begehren im Klassenraum neu-ordnen," in Aïcha Diallo, Annika Niemann, and Miriam Shabafrouz (eds), *Untie to Tie #1: Colonial Legacies and Contemporary Societies—Koloniale Vermächtnisse und Zeitgenössische Gesellschaften*. Berlin: Institut für Auslandsbeziehungen, 2021, pp. 222 25.
2 Antonio Gramsci, *Antonio Gramsci: Selections from Political Writings (1910-1920)*, ed. Quintin Hoare, trans. John Matthews. New York: International Publishers, 1977, p. 666.
3 Even if this pedagogical relationship extends far beyond school.

Gramsci illustrates how the historical-social order is decisively shaped by processes of education and upbringing, producing forms of consciousness and worldviews.[4] Narratives inscribed in curricula are crucial for forming the perception of the world and the structuring of social power relations, as is the national language prevalent in schools, even though migration-related multilingualism has long been a fact.[5] This is how educationalist Natascha Khakpour describes it, defining the topos of language in a society with a significant migrant population, with reference to Gramsci, as "hegemonic language and speech relations."[6] As a system of thought invented in Europe, the colonial racist legacy is also reflected in its languages. German, too, is considerably influenced by racist discourses.[7] Language and the written word significantly determine our ideas about the world—culturally, socially, politically, and so on. Language preserves the conception of the world "mechanically 'imposed' by the external environment," as Gramsci says.[8] The key space of this external environment is school, where young people rehearse the values of society within a static hierarchical structure. The linguistic order becomes the dominant order. Thus, as writer and sociologist Albert Memmi puts it, the texts that legalized the illegal colonial appropriation of land, resources, and people had to be written first.[9] These colonial narratives also created the terminologies and labels that reinforce and sustain them. For example, to demonstrate their superiority, the colonizers labeled the

4 Armin Bernhard, "Antonio Gramscis Verständnis von Bildung und Erziehung," *UTOPIE Kreativ*, no.183 (January 2006), pp. 10–22, here p. 10.
5 Natascha Khakpour, "Schools as the Terrain for Struggles Over Hegemony," in Lydia Heidrich, Yasemin Karakaşoğlu, Paul Mecheril, and Saphira Shure (eds), *Regimes of Belonging—Schools—Migrations*. Wiesbaden: Springer Fachmedien, 2021, pp. 125–143, here p. 96.
6 Natascha Khakpour, *Deutsch-Können. Umkämpftes Artikulationsgeschehen in den Schulen*. Weinheim: Beltz Juventa, 2022.
7 See Susan Arndt and Nadja Ofuatey-Alazard, "Warum wir über Rassismus sprechen müssen, ohne es eigentlich zu wollen," in Susan Arndt and Nadja Ofuatey-Alazard (eds), *Wie Rassismus aus Wörtern spricht. (K)Erben des Kolonialismus im Wissensarchiv deutsche Sprache. Ein Kritisches Nachschlagewerk*. Münster: Unrast-Verlag, 2011, pp. 11–17.
8 Antonio Gramsci, *Selection from the Prison Notebooks*, ed. Quintin Hoare, trans. John Matthews. New York: International Publishers, 1971, p. 323.
9 Albert Memmi, *Portrait Du Colonisé. Portrait Du Colonisateur*. Paris: Gallimard, 1957, p. 73.

colonized with animal names. In the words of theoretician, writer, and psychiatrist Frantz Fanon: "The terms the settler uses when he mentions the native are zoological terms."[10] The (de)colonial glossary by artists Aliza Yanes Viacava and Santiago Calderón García illustrates how in the course of European history language was used to dominate the world.[11]

The colonizers' narrative of superiority is accompanied by a narrative of inferiority on the part of the colonized. It seeps all the way into the unconscious, the place where we are influenced the most without being conscious of it.[12] Frantz Fanon has shown how the colonial collective unconscious, the "sum of prejudices, myths, collective attitudes of a given group," is culturally produced to sustain power relations.[13] The unconscious is also the seat of desire. Following philosopher Gilles Deleuze and psychoanalyst Félix Guattari, I regard desire as an essential force that brings about the reality of human beings in their relationships with other human beings and things in their environment.[14] The deepest consensus with the social order in Gramsci's sense is that colonized subjects must desire their own oppression. For psychoanalyst and art critic Suely Rolnik, the colonial unconscious structures our subjectivities, desires, and thought production.[15]

10 Frantz Fanon, *The Wretched of the Earth*, trans. Constance Farrington. New York: Grove Press, 1981, p. 42.
11 See Aliza Yanes Viacava and Santiago Calderón García in this volume, pp. 33–53.
12 See Gregory Bateson, "Style, Grace, and Information in Primitive Art," in Gregory Bateson, *Steps to an Ecology of Mind*. San Francisco, CA: Chandler, 1972, p. 117.
13 Frantz Fanon, *Black Skin, White Masks*, trans. Charles Lam Markmann. London: Pluto Press, 1986, p. 188.
14 See Leila Haghighat, "Schizophrenie und Ästhetik. Eine ideengeschichtliche Auseinandersetzung mit dem Double Bind," in María do Mar Castro Varela and Leila Haghighat (eds), *Double Bind postkolonial. Kritische Perspektiven auf Kunst und Kulturelle Bildung*. Bielefeld: transcript, forthcoming.
15 Suely Rolnik, "The Micropolitics of Thinking: Suggestions to Those Who Seek to Deprogram the Colonial Unconscious," paper given at the public symposium as part of the exhibition *Under the Same Sun: Art from Latin America Today*. The Unknown University, New York, September 19, 2014, Solomon R. Guggenheim Museum, youtube.com/watch?v=yASMCTAHiVM, accessed August 17, 2022.

The desire of the (colonial) unconscious is directed and corrupted by the micropolitics of the dominant colonial-capitalist regime.[16] Language and images dictate what is socially desirable. This is instilled through the continuity and constant repetition of capitalist and Eurocentric narratives, for instance, in cultural products and educational materials that impress themselves on the collective unconscious. To counteract these powerful mechanisms, according to Rolnik, it is necessary to hold on to desire and use it to dissolve the colonial unconscious, subvert it, create something new, and finally decolonize consciousness.[17] This involves listening to desire and countering the dominant colonial-capitalist regime with other narratives, languages, and images. Here, the demand of postcolonial theorist Gayatri Chakravorty Spivak for an uncoercive rearrangement of desires for the project of education comes into play.[18]

To break free from the habits ("of thought") deeply rooted in our unconscious, dominated by the capitalist-colonial unconscious, work on the imagination is necessary. According to Spivak, only an aesthetic education is capable of appealing to the imagination by showing that things can be different from what they are, appear to be, or are represented as.[19] Art thereby becomes "an exercise in communicating about the species of unconsciousness" as Gregory Bateson puts it.[20] Similarly, justice and responsibility must first be learned, requiring a reorganization of desire through a continuous "training of the habit of the ethical."[21] In addition, artistic explorations and counternarratives are important instruments of resistance. This constitutes an emancipatory education in Gramsci's sense, aiming at inner and outer self-determination.[22]

16 See Suely Rolnik, "The Spheres of Insurrection: Suggestions for Combating the Pimping of Life," *e-flux Journal*, no. 86 (2017), e-flux.com/journal/86/163107/the-spheres-of-insurrection-suggestions-for-combating-the-pimping-of-life/, accessed August 17, 2022.
17 Rolnik, "The Micropolitics of Thinking."
18 Gayatri Chakravorty Spivak, *An Aesthetic Education in the Era of Globalization*. Cambridge, MA: Harvard University Press, 2012, pp. 2, 18.
19 Ibid., pp. 2–29.
20 Bateson, "Style, Grace und Information in Primitive Art," p. 114.
21 Spivak, *An Aesthetic Education in the Era of Globalization*, p. 9.
22 See, for example, Bernhard, "Antonio Gramscis Verständnis von Bildung und Erziehung."

It also involves an examination of language and its inherent possibilities for a counterhegemonic reappropriation of the world. As I have tried to show, language and art act as mediators between the unconscious and power relations. Thus, the aforementioned colonial glossary not only contains terms that oppress but also those that resist: a counterlanguage and a counterspeech of those who are confronted with the consequences of racist speech and action.[23] Resistance to colonial exploitation has always existed. Yet it had to remain invisible so as not to disrupt the narrative of superiority. School not only reinforces existing conditions but also offers space and possibilities for resistant practices.[24]

For this piece, I was asked to describe the disease of colonial continuity and art as its medicine. Spivak, however, points out that aesthetic education, as a legacy of the Enlightenment, forms a substantial part of the canon responsible for the disease and is therefore in a double bind. In this sense, we must see art as what philosopher Jacques Derrida calls *pharmakon*, as both poison and medicine.[25] It remains a work without guarantees, as Spivak says. But it is necessary work, because it is the only way to reassess and recast the existing colonial continuities operating in both images and language.

Translated from the German by Kevin Kennedy

23 See Arndt and Ofuatey-Alazard, "Warum wir über Rassismus sprechen müssen, ohne es eigentlich zu wollen," p. 11.
24 See Khakpour, "Schools as the Terrain for Struggles Over Hegemony," p. 99.
25 Jacques Derrida, *La Dissémination*. Paris: Éditions du Seuil, 1972.

+ Anna Bartels studied Cultural Studies, Romance Languag-
es and Literature at the University of Bremen and the Universi-
tat de València, focusing on cultural anthropology and youth
(sub)cultures. From 2017 to 2022 she was Coordinator for Cultural
Education at Haus der Kulturen der Welt, mainly responsible
for supervising participatory art projects with schools and
young people.

+ Laida Hadel studied American Studies, English Studies,
and Gender Studies in Berlin and Konstanz. From 2014 to 2022
she worked in the field of communication and cultural education
at Haus der Kulturen der Welt, where she coordinated artistic
research projects with schools on the topic of future learning.
Since September 2022, she has been a research associate
at Haus Bastian – Center for Cultural Education of the Berlin
State Museums.

+ Daniel Neugebauer works as curator for mediation and
strategic partnerships at Haus der Kulturen der Welt in Berlin.
He is also a Fellow at the Vrije Universiteit Amsterdam. Previous-
ly, he was head of the Communication and Cultural Education
department at Haus der Kulturen der Welt. 2012–2018 he was head
of marketing, mediation and fundraising at the Van Abbemuseum
in the Netherlands. In 2016/17, he coordinated the marketing of
documenta 14 in Kassel and Athens. In recent years, the concept
of corpoliteracy has been the focus of his institutional practice,
implemented, for example, in an educational concept for the
Romanian pavilion at the Biennale di Venezia 2022.

+ Eva Stein is a curator for mediation at Haus der Kulturen der Welt. She studied German and Journalism at the Freie Universität Berlin, initially working as a freelance journalist before becoming an Internet editor at HKW. In 2017, 2018, and 2021, she was Project Director for *Schools of Tomorrow*, an enterprise that explores how school-based learning prepares young people for the society we live in today.

\+ Santiago Calderón García is an artist working in the field of art mediation and cultural education. With focus on the development of participatory projects in school contexts and extracurricular learning spaces, his work involves practices such as screen printing, drawing, and video. He has been conducting art and media education projects with children and teenagers in Bogotá and Berlin since 2010.

\+ Leila Haghighat works in the cultural sector in Berlin and is currently completing her PhD on participatory art in the context of gentrification at the University of Applied Arts in Vienna. She studied Cultural and Political Science at the Université Paris VIII and was Coordinator for Cultural Education at Haus der Kulturen der Welt. Both her professional work and research focus is on participatory practices and knowledge production in art and cultural education and on the relationship between art, politics, and society.

\+ Franziska Pierwoss is a Berlin-based artist working in the field of performance and installation. She studied at the Leipzig Academy of Visual Arts and the Lebanese University of Beirut. Her often ephemeral works—the creation of temporary situational installations that question personal and political relationships— have been shown at Fast Forward Festival Athens, Sharjah Biennial 13, Paco Imperial (Rio de Janeiro), and Halle 14 (Leipzig), among others. Over the past decade or so, Pierwoss has collaborated with artist/curator Sandra Teitge on issues relating to the political, social, and financial economics of waste management. She also works as a transformation manager conducting workshops on implementing environmental sustainability.

+ Siska lives and works in Berlin. He graduated in Film Studies and Directing from the Lebanese Academy of Fine Arts in Beirut. Siska's artistic practice focuses on archival methods that explore sociopolitical narratives about personal and collective pasts. His work has been shown at Gropius Bau, Berlinale – Berlin International Film Festival, Paris 104, Beirut Exhibition Center, and the Mosaic Rooms in London, among others.

+ Aliza Yanes Viacava holds a bachelor's degree in Literature from the Universidad Nacional Mayor de San Marcos (Lima, Peru) and master's degrees in Latin American Studies (Freie Universität, Berlin) and "Art in Context" (Universität der Künste, Berlin). Yanes' artistic practice combines research, creative writing, mediation, video, and performance. With extensive professional experience that began in Peru organizing cultural events, she is currently engaged in educational and cultural work to question and disrupt Eurocentric thought patterns within arts, cultural, and educational institutions.

rehearse

Photos of the stop-motion workshop by Santiago Calderón García and Aliza Yanes Viacava on pp. 2–7, 70–75: Elkin Calderón

Yee Sou Romotow,
Working Process

Das (de)koloniale
Glossar

Colophon

Published by: Spector Books
Harkortstr. 10, 01407 Leipzig
www.spectorbooks.com

Das Neue Alphabet (The New Alphabet) is a publication series by HKW (Haus der Kulturen der Welt).

The series is part of the HKW project *Das Neue Alphabet* (2019–2022), supported by the Federal Government Commissioner for Culture and the Media due to a ruling of the German Bundestag.

Series Editors: Detlef Diederichsen, Anselm Franke,
 Katrin Klingan, Daniel Neugebauer, Bernd Scherer
Project Management: Philipp Albers
Managing Editor: Martin Hager
Copy-Editing: Mandi Gomez, Hannah Sarid de Mowbray
Design Concept: Olaf Nicolai with Malin Gewinner,
 Hannes Drißner

Vol. 23: *Talkback Circuits: New Alphabets at School*
Editors: Anna Bartels, Laida Hadel, Daniel Neugebauer,
 and Eva Stein
Coordination: Laida Hadel, Anna Bartels
Contributors: Santiago Calderón García and Aliza Yanes Viacava,
 Leila Haghighat, Franziska Pierwoss and Siska
Translations: Kevin Kennedy
Graphic Design: Malin Gewinner, Hannes Drißner,
 Markus Dreßen, Lyosha Kritsouk
DNA-Lettering (Cover): Dorian Delnon
Type-Setting: Lyosha Kritsouk
Fonts: FK Raster (Florian Karsten), Suisse BP Int'l (Ian Party)
 Lyon Text (Kai Bernau)
Image Editing: ScanColor Reprostudio GmbH, Leipzig
Printing and Binding: Gutenberg Beuys Feindruckerei GmbH,
 Langenhagen

Distribution:
Germany, Austria: GVA Gemeinsame Verlagsauslieferung
 Göttingen GmbH & Co. KG, www.gva-verlage.de
Switzerland: AVA Verlagsauslieferung AG, www.ava.ch
France, Belgium: Interart Paris, www.interart.fr
UK: Central Books Ltd, www.centralbooks.com
USA, Canada, Central and South America, Africa:
 ARTBOOK | D.A.P. www.artbook.com
Japan: twelvebooks, www.twelve-books.com
South Korea: The Book Society, www.thebooksociety.org
Australia, New Zealand: Perimeter Distribution,
 www.perimeterdistribution.com

Haus der Kulturen der Welt
John-Foster-Dulles-Allee 10
D-10557 Berlin
www.hkw.de

Haus der Kulturen der Welt

Haus der Kulturen der Welt is a business division of Kultur-
veranstaltungen des Bundes in Berlin GmbH (KBB).

Director: Bernd Scherer
Managing Director: Charlotte Sieben
Chairwoman of the Supervisory Board: Claudia Roth MdB
Federal Government Commissioner for Culture and the Media

Haus der Kulturen der Welt is supported by

 Minister of State
for Culture and the Media

 NEU
START
KULTUR

 Federal Foreign Office

First Edition
Printed in Germany
ISBN: 978-3-95905-662-5

Das Neue Alphabet (The New Alphabet)

Vol. 5: *Skin and Code*
Editor: Daniel Neugebauer
Contrib.: Alyk Blue, Luce deLire, i-Päd, Rhea Ramjohn, Julia
 Velkova & Anne Kaun
ISBN: 978-3-95905-461-4

Just as physical violence leaves its marks on the skin, concep-
tual violence is written into interfaces via algorithms—in the
form of biases turned into pixels, as discrimination implanted In
memes in secret chat groups. The coding and decoding of body
surfaces and interfaces is contingent on a whole host of norms.
Yet these are not fixed: rather, they combine to create a matrix
of tastes, cultural influences, technical conditions, and physical
possibilities. The essays in this volume produce an interdiscipli-
nary noise between surface structures and a selection of cavi-
ties: surfaces, skins, and interfaces are injured, gauged, altered,
or remedied.

Vol. 6: *Carrier Bag Fiction*
Editors: Sarah Shin, Mathias Zeiske
Contrib.: Federico Campagna, Dorothee Elmiger, Ursula
 K. Le Guin, Enis Maci a.o.
ISBN: 978-3-95905-463-8

What if humanity's primary inventions were not the Hero's spear but rather a basket of wild oats, a medicine bundle, a story. Ursula K. Le Guin's 1986 essay *The Carrier Bag Theory of Fiction* presents a feminist story of technology that centres on the collective sustenance of life, and reimagines the carrierbag as a tool for telling strangely realistic fictions. New writings and images respond to Le Guin's narrative practice of worldmaking through gathering and holding.

Vol. 7: *Making*
Editors: Nick Houde, Katrin Klingan, Johanna Schindler
Contrib.: Luis Campos, Maria Chehonadskih, Reece Cox, Ana
 Guzmán, Hao Liang, Hu Fang, Elisabeth Povinelli,
 Kaushik Sunder Rajan, Sophia Roosth
ISBN: 978-3-95905-465-2

Who produces what, and how? What tools and technologies, what values and intentions are fed into the process? What part do power and control play in the context of semi-autonomous technologies that will shape our future world? The book's essays, conversations, and artist contributions focus on the practices and politics of production as a response to our contemporary processes of planetary transformation.

Vol. 8:	*Looking at Music*
Editors:	Lina Brion, Detlef Diederichsen
Contrib.:	Stefanie Alisch, Peter Kirn, Mari Matsutoya, Adam Parkinson, Terre Thaemlitz, TOPLAP
ISBN:	978-3-95905-492-8

The performance of computer-produced music has broken with the codes of the concert: The audience can no longer watch music being created; the causal relationship between gesture and sound has been cut. With laptop performances, a format has emerged in which the audience stares at people staring at screens. *Looking at Music* asks: What role does visibility play in the experience of music? How important is the live character to the future of music performance? Screen views at "algoraves" or virtual reality stars like Hatsune Miku reintroduce visual stimuli on different levels; in kuduro, the musical focus is on the dance expertise—whilst other musicians have long left the stage-centered spectacle behind.

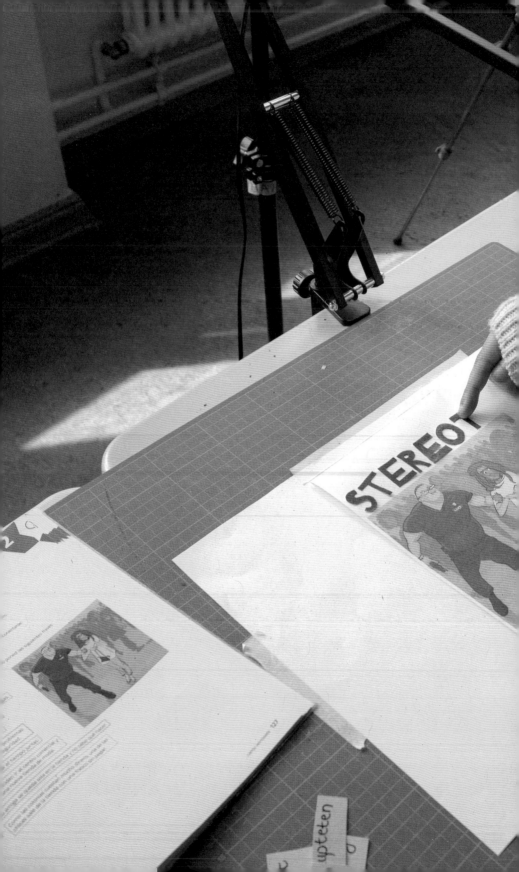

Lern-
gruppen-
Regeln

"FAiRE ALLER"

1 Respektvolles Verhalten

2

3

LOB

Tadel

FAIS
FAIS
FAIT
FAISON
FAITES
FONT

ALLO
ALLER
VONT

EZ
ENT